Praise for
Poems for Josefina / Poemas para Josefina
by Marjorie Agosín

A book of tenderness and great beauty. One of the most beautiful contemporary books of Latin American poetry.
—Antonio Skarmeta, author of *El Postino*

A passionate tribute to a passionate woman. A collection of great beauty and tenderness.
—Claribel Alegría, author of *Thresholds*

Marjorie Agosín has written a wonderful tribute to her grandmother and the many decent and often forgotten people who have lived the relentless changes of the 20th century. The imaginative elegance of these poems comes from believing in the ephemeral and forgetting time. Personal moments are illuminated like morning light seen through a nightgown at the foot of the bed. Through this collection, Agosín reconciles her exile with Josefina and in a greater sense with Chile.
—Ram Devineni, Editor, *Rattapallax*

The life and death of Hanna Josefina Agosín, a Jewish woman who emigrated as a child from Argentina to Chile in the early 20th century, is lovingly portrayed by her granddaughter. Marjorie Agosín eloquently describes the experiences, images, and memories surrounding the deep ties between her grandmother and herself, framing her narrative with the Jewish customs of a small sector of Chile's middle class that was defined as much by elegance and national pride as by the ruptures of forced exile in the aftermath of the military coup of 1973. These poems are a testimony to the significant role that memory plays in the lives of diasporic peoples everywhere.
—Suzanne Oboler, Editor, *Latino Studies*, University of Illinois, Chicago

Poems for Josefina
Poemas para Josefina

ALSO AVAILABLE BY MAJORIE AGOSÍN
FROM SHERMAN ASHER PUBLISHING:

Invisible Dreamer: Memory, Judaism, and Human Rights
Lluvia en el desierto / Rain in the Desert
Miriam's Daughter: Jewish Latin American Poets

Poems for Josefina

Poemas para Josefina

by Marjorie Agosín

Translated by Betty Jean Craige

Sherman Asher Publishing / *Santa Fe*

Copyright © 2004 Majorie Agosín

Library of Congress Control Number: 2004111942

All rights reserved.

This book was made possible in part through the generosity of Wellesley College
Book design by Jim Mafchir
Cover and title page illustration:
Dialeg sobre Tauia. Lithograph by Alvar Suñol. *Photo by Betty Jean Craige*
Edited by Nancy Zimmerman

Sherman Asher Publishing
P.O. Box 31725
Santa Fe, New Mexico 87594-1725
e-mail: westernedge@santa-fe.net
www.shermanasher.com
tel: (505)988-7214

Contents

Acknowledgments	viii
Introduction: My Grandmother Hanna Josefina	1
Section 1	17
No hay otra luz / **There Is No Other Light**	
No hay otra luz / There Is No Other Light	18
Shiva / Shiva	20
Pensando en Santa Teresa / Thinking about Saint Teresa	22
Cerca del agua / Near the Water	24
Fue dulce tu muerte / Your Death Was Sweet	26
El jardín de Josefina / Josefina's garden	28
Rosal / Rosebush	34
Dicen / They Say	36
Section II	39
Deshaciendo una vida / **Undoing a Life**	
Deshaciendo una vida / Undoing a Life	40
Kaddish / Kaddish	44

Tú regresas / You return	50
Domingos / Sundays	54
Tu voz / Your Voice	58
Las ceremonias del adiós / The Ceremonies of Good-bye	62
Para prolongar tu vida / To Extend Your Life	66
La coleccionista / The Collector	68
Regresos / Returns	72
Aprendí a jugar / I Learned to Play	74
Pertenencias / Belongings	78
Palpar una lejanía / To Feel a Distance	82
No quise censurar / I Did Not Want to Criticize	86
Paisajes / Landscapes	90

Section III 93
Canto / **Song**

Canto / Song	94
Camisas de dormir / Nightgowns	96
Tu bondad / Your Goodness	100
El cepillo de nácar / Mother-of-Pearl Brush	102
Los espejos / Mirrors	108
Tu elegancia / Your Elegance	110
Entre tus pasiones / Among Your Passions	112
Los pisos de arena1 / Floors of Sand	118
Hollywood / Hollywood	124
La cocina / The Kitchen	128
La tierra / The Earth	132
La plaza de tu pueblo / The Plaza of Your Town	134
La prisa / Haste	138

El café / The Café	140
Mi abuela murió en Chile /	
My Grandmother Died in Chile	142

Section IV 147
Ahora que no estás / Now That You Are Not Here

El alma busca lugares / The Soul Seeks Places to Be	148
Los cumpleaños / Birthdays	150
El Belloto / Belloto	156
Hierbabuena / Mint	160
Se aplaca el deseo / Desire Is Appeased	162
Los años / The Years	164
Frente / Forehead	166
El rezo de una memoria / A Memory's Prayer	168
Entre los pinos / Among the Pines	170
Adiós / Goodbye	174

About the Author	**176**
About the Translator	**177**

Acknowledgments

The poems in this collection surfaced as I began wrestling with the finality of death in August of 2002. They are inspired by Josefina Agosín Halpern, my grandmother, who lived a wondrous life in her native land of Chile and who died where she always wanted to die: at home, waiting for her dinner to arrive. My grandmother was humorous, kind, often too honest, and always guided by a sense of truth and inner justice. The poems evoke and recreate her life, tell of her wonderful eccentricities, and share the process of grief that accompanies the acknowledgment of a loved one's death.

So first I want to thank the spirit of my grandmother, who seems always to be next to me, watching over my shoulder, sometimes scolding me, other times making her appearance as a butterfly.

I am deeply grateful to my translator Betty Jean Craige for her superb and sensitive translations and for her conscientious work on the manuscript as a whole. She believed in this project from the beginning, and she guided me in shaping many of the poems.

I thank Monica Bruno for her typing of the Spanish poems and for her continued support of my work through the years.

We also thank Stacy Smith, at the University of Georgia Center for Humanities and Arts, for her proofreading of the translations.

We also thank our wonderful friend Alvar Suñol, of Barcelona, for permission to use the image of his lithograph "Dialeg sobre Taula" for the book's cover.

This project has turned my mourning into an expression of love for a unique, delightful woman.

Josefina at age 16, beautiful and sought-after by many suitors. She grew up in an atmosphere of luxury—her father taught her to drive, and she used to attend operas and concerts. Even after her family lost its fortune, she continued to live her life with the same joy, hope, and aspirations.

Introduction:
My Grandmother Hanna Josefina

My grandmother Hanna Josefina died on July 29, 2002. Her two names, like the story of her life, reveal the extraordinary travels of her soul, the journeys she desired to take and those she did not. Her life, more than anything else, celebrated stability, as in her love for Chile, that long, narrow, mysterious country she never left. While my family joined the great human wave of exiles, emigrants, and dispossessed, forced to succumb to the vicissitudes of history, Hanna Josefina knew that she would find her security through her roots in her native land, which turned out to be one of the most valuable legacies that she, perhaps unintentionally, would leave us: the sense of belonging to a place, the attachment to familiar things.

The physical distance that separated us from my grandmother during more than 30 years of exile prevented our presence at her burial. The farewell ceremony, imagined from afar, is incomprehensibly painful for people who have been prohibited by the force of history from returning to the homeland. For those who have forever lived in one place, births, marriages, and deaths form a natural part of daily life. But for those estranged from their homeland, the ceremonial events evoke envy and inexpressible nostalgia:

simultaneously, the desire to be there and the recognition that exile delineates borders that cannot ever be crossed again, borders that appear only in the maps of the imagination and the soul.

My grandmother died in the company of the faithful family maid, Delfina Nahuenhual, who never abandoned her. Delfina is for us like a Mapuche princess warrior— short of stature and occasionally short-tempered, but loyal and persistent. Now Delfina is the one who occupies the home, the one who will tell us how my grandmother died and how she lived. Having lived with her day in and day out, Delfina is the person who will frame the memory of my grandmother and deliver her last days to us. We are left with only our imagination, and our sporadic trips to the country that was once ours, which now takes the form of a postcard image of the country we visit, like tourists returning to a place of which we will never truly be a part. We are foreign relatives, or guests, and we feel uneasy, unsure of who we are.

My grandmother died on a day of white clouds and black clouds, of sunshine and rain. She died as a Jew and was interred in the Jewish cemetery of El Belloto where she rests on the outskirts of Viña del Mar. To reach it, you must cross the lavender fields of Limache, the mallow hills, the fruit and avocado plantations. It is a very small cemetery for the area's one thousand Jewish people.

Our history may be discerned more easily perhaps among the dead than among the living. Walking through the Belloto cemetery, we begin to discover the story of our origins. That cemetery is the surest sign of permanence, enabling us to understand how we arrived in Chile, why we stayed, and how the country that took us in and gave us life then brought us self-recognition in death.

On nights of insomnia, I mentally wander through the

Josefina Agosín and her husband, Joseph Halpern, on their wedding day, December 31, 1905, in Valparaíso, Chile. They were married in Palacio Polanco, a former home of Chilean aristocrats, in front of more than 400 people. Among the guests were Jews, Catholics, and a number of Russians, as her father, Marcos Agosín, was the honorary Russian consul in Valparaíso. The nuptial celebrations lasted almost two full days, and it was said that this wedding was similar to Chile's weeklong gypsy weddings. Josefina and Joseph were married for 52 years.

Belloto cemetery. My father says that in his childhood he lived near a cemetery, where the dead were more familiar company to him than the living. For me, this cemetery has meant a homecoming, a journey where memory takes us beyond the tombstones. It is a space where one feels love and absence.

My grandmother Josefina lies behind my other two

grandparents, Abraham and Raquel Agosín. They are the ones who receive visitors, and their graves are the first the visitors encounter. Those grandparents were from Odessa, but they passed through many ports, many countries, before they arrived at their final destination, the city of Quillota in the central valley of Chile. There they prospered as tailors, following the trade they had learned in Russia, the only trade permitted to Jews. They lived in Chile for more than 50 years. They learned to speak Spanish and to participate in local festivals. They educated their children, and they became beloved members of the community. Although they wore odd clothes—they were Russian eccentrics in the little town of Quillota—nobody pried into their lives or into their background. For them, Chile was a place of peace, a safe haven, where they could erase their past as tormented refugees and achieve their long desired repose, in life and in death.

Josefina was born in the New World in the year 1904 in Buenos Aires, in the Jewish district of Calle Once. She was the daughter of a tailor and a seamstress who, according to legend, sewed for the czarina at her summer palace in Odessa. Russian was one of her first languages, as was Yiddish, but she gave up both in her love of Spanish. I don't know whether she retained any of the Russian songs her mother Sofía would sing to her, but Chepita—as we all called her—clung passionately to her new life in the country that would witness her joys and sorrows, the country that she made her own by her insistent attachment to a single place.

My grandmother had a gift for telling stories. She would tell them and retell them, reinventing them, sometimes to maximize excitement and sometimes to minimize it, according to the mood of her audience. Listening to her turned me into a writer. My grandmother demanded

respectful silence and complete attention from her audience during her narrations. She would develop her characters fully, to show the extremes of their personalities, but she would reveal little about herself and would always maintain a personal barrier I found impossible to cross. Even so, she had a reputation for frankness, which her friends considered both a virtue and a fault. I have thought often about the things she never said, and about the myths that little by little we created around her. But my grandmother was born to narrate the life of others and to hide her own secret sorrows in a mysterious trunk under her bed. She also had the habit of giving us sealed envelopes to open after her death. We still don't dare open the envelopes, preferring to leave them sealed, so that her words and promises may remain alive—because I want to love her and remember her in the fullness of her life. That may be why fate prevented my going to Chile to see her die.

My grandmother loved all aspects of dressing up, from the rice powder she used for her face to her big yellow straw hats. She was truly flamboyant. She said that she did not want to be buried, because paradise was here in the music of the dance and in the tales that she, like Scheherazade, told to overcome sorrows and bear witness to the living.

Relatives and friends say that the day my grandmother died the sky opened to let her pass through, and in the middle of the black clouds a rainbow appeared, bright with the colors of heaven. That sign was an emblem of her life. My grandmother was not a gloomy person. She loved being with people, hearing the sound of the buses, sitting in the cafés eating apple pie. She had no time for the rest that death offered her, so she fought death until finally she lost the battle, and then she went, in hopes of passing from one form of happiness to another.

I should tell how she arrived in Chile—her adventures

on the trip, her fears. For persecuted Jews, like for most other emigrants, life is not easy. For my great-grandfather Marcos, a tailor, competition with the other emigrants was stiff. He had heard that in Chile, gold sparkled in the streets and that the people there were generous and healthy. He reported that to my great-grandmother Sonia Sofía, who asked whether it would be good or bad for Jews. She always had her suitcases packed, ready to travel. So he told Sonia Sofía—or Sofía Sonia—that Chile would be good for Jews and that they should go. She packed her belongings, of which there were few, since she always had to pack in a hurry and thus would lose half her things. But she always managed to take her tape measure and her thimble.

My grandmother was only two years old at the time, and she was called Hanna, not Josefina. The three of them traveled on the trans-Andean train that took them from the port of Buenos Aires to Mendoza. Of that journey I know little. It was seldom mentioned, seldom remembered. But I did learn of their traversing the mountains by mule. That story is the one that Josefina always told to begin the marvelous mythology of her life that she created for us. When they left Mendoza to cross the border into Chile, the immigration officials could not understand her name and substituted a J for the H and called her "Josefina." She always loved the name, which once an empress bore, but she asked that she be called Chepita—not Chepa, and certainly not Josefa. Thus my grandmother arrived in Chile with a brand-new name and a beautiful history to make for herself.

At times when the two of us—my grandmother and I—went out on the balcony of her house in Viña del Mar, we'd see the heavens sprinkled with stars like nocturnal gardens. She would talk about their crossing over the mountains at night, with the mule drivers singing, and she would tell about their enthralling solitude. She would say that her

mother kissed her to alleviate the effects of the mountain cold and that she still remembered the fierce wind that howled through the open spaces, through the strange stillness.

In spite of that unforgettable trip, my grandmother was not a fan of long walks. She preferred to stay at home watching the clock. She did that often, and she loved feeling that time was not passing, though everything, and nothing, was happening. She would say to me that she did not like seeing the hours go by quickly. Permanence was what she held most dear, yet from childhood on she liked to walk around the port of Valparaíso, and she would be overcome with emotion watching the arrival and departure of ships and the parting of lovers on the docks.

The Agosín family settled in Valparaíso in 1904. They were poor but enterprising. The astuteness and audacity of my great-grandfather enabled them to build a comfortable life for themselves fairly quickly, and enabled Josefina to honor her name and live like a princess. Her brother Gregorio told me that Josefina died like a queen, and I know that she certainly lived like a queen. In her youth she got the nickname "Princess of the Polanco Palace," which is what people called the building they lived in. That turn-of-the-century building had the Pacific Ocean in front of it and the rolling hills that surrounded the city, each with its own poetic name—Cerro Alegre, Hill of Happiness, and Cerro Las Mariposas, Butterfly Hill—behind it. From the

The author's mother, Frida Agosín Halpern, on the day of her wedding to Dr. Moisés Agosín, June, 1948, the same day the state of Israel was founded. Frida and Moisés have been married for 54 years and live in Athens, Georgia.

balcony, my grandmother dreamed of long trips, adventures, walks.

Josefina could go hear Caruso, dance with the prince of Hapsburg, own the first automobile in the district, wear a bathing suit, and in general take pleasure in the leisure that wealth provided. She was not a spendthrift, though she knew how to live the good life, without showing off, either when she was rich or when she was poor. She threw herself into living in good style, never forgetting her "princess" habits. She enjoyed feeling—and being—pretty, and she would dust her nose with fine rice powder and fan herself both in cold weather and in hot. She wanted her dinner served to her after dark. It was only chickens who ate early, she said.

Josefina with Frida at age three in Tacna, northern Chile.

When my great-grandfather lost his fortune at the casino and her six younger siblings sank into poverty and despair, Josefina retained the look of a sultana, though without land and without palace. She kept her history locked up within herself. She decided about that time to marry my grandfather Joseph Halpern, or José, whom some called a "crazy German," but whom she then—and I later—saw as a dreamer with deep green eyes dark as the forests of Chile.

When my grandmother got married, her family had already left the house in Polanco Palace, and her siblings were scattered throughout the district in boardinghouses. Her husband was elegant and noble, of good lineage, according to the neighbors. I know that she cared deeply for him, but she could not follow the bold paths of his dreams. They lived together for more than 50 years, and she loved and respected him, I would say, but at a certain dis-

tance, as was her way, and she kept her secrets to herself until the end of her days.

The early years of my grandmother's marriage were shaped by their poverty and the country's economic depression. Once again she became the insecure traveler she had been on that prophetic night that would mark her character forever when she crossed the mountains as a child. This time, like her parents, she and her husband went to the north of Chile, almost to its Peruvian border, to the city of Guara. My grandmother told me the story often. In the latest version, the majestic mountain disappeared to open a pass to the desert through which they rode sadly to their new abode. Their house in Guara had a dirt floor, just like the Arabs had, she said.

I imagine her in Guara with red hair and silk clothes—which she managed to acquire despite their financial situation—tall and self-confident, but facing an empty horizon, in a world without water, and without hope. Now that she has died, I imagine that in her last days she had the look of despair that people who know they are near death have. She frequently said that Guara was like this, like death, like the rough ground of abandoned cities and parks. After the passing of her first daughter Eva, who was buried in a small blue casket next to their house, which itself was next to the cemetery, my grandmother stopped attending funerals. From then on she could not comprehend why Jews would throw clods of earth over their dead. My grandmother and death lived together in a perpetual battle. The passage of time produced no reconciliation, and neither did her own demise.

After their stay in Guara they moved to the city of Tacna, which was already part of Chile, not Peru. There my mother was born and given the name "Frida," which in German means "peace." My grandparents were still very

poor, and my beautiful, delicate mother was bathed in the same watering trough where the animals were bathed before they were eaten. However, that did not keep her from maturing into an elegant lady with the distinguished appearance and demeanor of her forebears.

Northern Chile had brought Josefina penury and loneliness. But she was a clever woman, with a heart as bold as her behavior. She left Guara with her husband to go to southern Chile, to the city of Osorno, a place of water, rain, and flying fish. There my grandmother was happier, because she could go out on the balcony of her house and feel the rhythms of heaven and earth.

My grandfather tried out many different jobs, from traveling underwear salesman to owner of a small business. I want to remember him as the Viennese dreamer who created an association for the rescue of Jews during World War II. He was actually himself the whole association, and he rode the dilapidated trains of southern Chile to bring back grieving Jews—orphans, homeless people, the godforsaken—to whom he gave refuge in his home, and hope.

My grandmother's house in Osorno was forever noisy with the laughter of guests, and people were always coming and going. My grandmother was a generous hostess, whether presiding over the old wooden yellow house on the town plaza of Osorno or the houses they later had in Santiago. She required no rent, so nieces, nephews, distant cousins, and stray vagabonds came to spend time there. She used to say that she could give them only noodles, which were inexpensive but nonetheless good for the soul. It seems that all these former guests came to her funeral, and they spoke about her, recalling in particular her frankness and her passion for truth.

The penultimate journey my grandmother took was to Santiago, where she lived for almost 50 years. Jewish

refugees were the first visitors to her house on Errazuriz Street, and also to the house at 4898 Simón Bolívar, which we called *la palmera* because it had a big palm tree in the yard. It was just across the street from my house, and I had only to cross over at the corner to be there. That house of my grandmother's is the one I loved most, and the one I best remember, because I spent a good part of my childhood there with her. She would wait at her gate for me to return from school, and would give me delicious ice cream before dinner. On Sundays she would give me fried potatoes and Coca-Cola.

Josefina was not strict with her grandchildren. She demanded nothing of us other than that we learn to be together without arguing. She was not exactly a pacifist, but she said that quarrels brought nothing good and that parties were better, and that we should seek peace.

The author as a third-grader at the Union school in Santiago de Chile, a very anti-Semitic school she attended for two years. She then went on to the Hebrew Institute of Santiago, a happier place where she studied Hebrew and became a poet.

From time to time I would want to skip school, because the hard work wearied me. Then my grandmother would say to my mother that I could stay home, that what I might have learned in school that day I could always learn another day. I knew what advice my grandmother was giving my mother, and when she kissed me I winked at her. Josefina gave me everything I wanted, even perhaps against her own will. She bought me a cat that annoyed our neighbor because he urinated on her roses. She bought me many little chicks, which I—in vain—tried to train. But best of all, she would accompany me wherever I wanted to go without asking

questions, and she always carried her transistor radio to catch the latest news of robberies and other events. My grandmother was not a pessimist, but she did enjoy listening to reports on the crackling radio of the crimes in the neighborhood.

My grandmother and I would go frequently for tea to the Café Paula in the center of Santiago, where we would help ourselves to toast and huge cups of iced coffee with abundant servings of whipped cream and where she would entertain me with tales of her travels. She loved Italy, Israel, and America, to which she referred as a land of gangsters. Her commentary was not a bit subtle. She always spoke her mind, making clear to everybody exactly what she liked and what she hated. When I got older she took me with her on trips to Brazil, New York, Savannah, the Elqui valley, where we visited Gabriela Mistral, and San Felipe de los Andes, where we went to see Santa Teresita del los Andes, whose picture my grandmother carried in her wallet. My grandmother believed in both saints and angels.

While she had great adventures abroad, my grandmother always dreamed of returning to Valparaíso, where her parents and her siblings had lived, where the hills reminded her of her first outings with her husband José. To her, Valparaíso was a place of magic and permanence. She used to tell me that she knew of nothing more wonderful than watching the glimmering lights on the hills at night. Whenever I would return to Chile I would do the same: watch those lights on the hills and talk with my grandparents, and especially with my grandmother, who would always listen to me.

When my grandfather José died in 1977, Josefina packed up the enormous house on the corner with the palm tree and headed toward Viña del Mar, where she spent the last 25 years of her life.

The collapse of the government of Salvador Allende in 1973, the arrival of Pinochet, and the vicissitudes of exile divided our family, not just by national borders but also by politics. Our world seemed suddenly split between those who supported Allende and those who supported Pinochet. The political divisions caused fissures in the family that only time could repair. To those of us who became emigrants, leaving our country felt like being loaned out to another. North America felt like a waystation. We lived for letters, telephone calls, and the annual journey to Chile, which we always took in June, when the mountain loomed bold and bright. My grandmother would always ask us months in advance of our arrival what we would like her to cook for us—and she asked me that days before her death. I smiled, but I could not answer her.

For expatriates, contact with a prior life, with beloved places, helps us to anchor ourselves, to define ourselves, but more than anything to navigate through the two worlds to which we belong—or rather, the two worlds in which we live. My dear Chepi belonged to Chile, to the land we left behind, and her weekly letters helped us recapture our past, our childhood, which seemed suspended in an imaginary time.

The letters from my grandmother I keep in my nightstand with my most precious things, like the book in which I write down my poems and my dreams. Her letters reveal a remarkable interest in minutiae. My grandmother would describe in detail the daily lives of all the people she visited, the weather, what was blooming and what was dying. And her handwriting always made us smile—big, exuberant characters, the i's dotted with large flowers. She would close her letters with a grand flourish: "Your Chepita."

Those letters, sent punctually every Monday, were the greatest treasure my grandmother left me. Through her words, her passion, her storytelling, the letters kept us con-

nected. Thus I learned that writing requires many ingredients: a grandmother like mine, a talent for telling, retelling, and reinventing stories, and—perhaps most essential—the knowledge that writing is indispensable play, the coming and going of fantastic ideas populating our daily lives.

During the 25 years my grandmother lived in Viña del Mar, I visited her every summer. Our routine was to have coffee at midday and spend the time watching the passers-by and the other café patrons. That street was her kingdom, and she was the sovereign of the numerous people—some whom she knew and some whom she did not—who greeted her. We talked about many things, most often about language and about the importance of keeping one's word, and about loyalty. We also spent endless hours speculating about the travels of family members. This, she said, was what being Jewish was all about. Her voice, like her handwriting, radiated life.

My grandmother could remember everything about the places she had visited, such that she had no need to return to them. Such recall was another one of the virtues she instilled in me, besides the cultivation of imagination and extravagant inventiveness. All those gifts that I have as a writer I attribute to her abilities as a poet and storyteller. I miss her now, for I will no longer receive her letters, nor will I hear her voice. I will never again have the thrill of knowing that she awaits my arrival in Chile. So I will have to resort to imagining that she is still there for me to write long letters about my dreams and my plans for the future. I know that in the space between the worlds we inhabit now we are together.

Last night I felt that she was returning to me in the form of a butterfly, a red and mischievous butterfly. This morning when I awoke I imagined her blue satin blouse on my body. I want to visit her grave, though I know that she

is everywhere and that she will come to me in the pleasures of life, which she so loved.

Josefina did not want to be buried in the ground. She did not want to be eaten by worms, she told me. But I know that she has become air and water and insubstantial things. That is why on the day she died, the rain stopped and the sky turned into a cape of luminous pearl. Wrapped up in her white sheet, she is smiling and telling stories.

I think that I will go back to Chile some day, to the city of Valparaíso, where I'll see her in the lights of the hills and I'll hear her in the café. Josefina Agosín has not departed at all, only changed her course. She is quieter now; she likes to be still when facing the sun. She wants people to visit her and to leave colored stones—as Jews traditionally remember the dead—on her grave. More than anything, I think, she wants people to write to her, because writing alleviates one's sorrows, forestalls death, and creates permanence.

I was not able to say good-bye to my grandmother, but I believe that is the way she wanted it. We did not like crying. We would don dark glasses and over the years would swear that we would always love each other and would see each other soon. I always feared her departure, and when it finally occurred I could not imagine a life without her. But I soon sensed that she had not gone, that she awaited my letters, that she wanted to give me the latest news about what was transpiring in her kingdom, such as the robbery of a carrot at the local market. So I began writing her a long letter, saying: Dear Grandmother, when you awaken from one dream to enter another I will be at your side in the great realm called memory, called love.

My grandmother was interred with all the rituals of Judaism. I will go back to Chile to visit her grave. And I will always remember her words, that the true paradise is here on earth. My grandmother's faith existed in the zones of the

spirit. For her, the sacred was the laughter of people, the fruits of the orchard, the sea. She lived in the present as she lived in the pleasure she took from all that she encountered.

*Josefina and Marjorie in Viña del Mar, 1996
during their afternoon strolls.*

Before she died my grandmother said that she wanted all of her clothes—her coats, her wool sweaters, et cetera—to be donated to Hogar de Cristo for the poor children of Chile. For me, that is the way to live and die in peace, with the hope that Christians and Jews may live together in harmony.

I close my eyes as I finish this essay, sensing the caress of the fluttering wings of a copper-colored butterfly. It is she who has lighted on my hands, the hands that once held her face, the hands that now write these words, which will be my path to memory.

SECCIÓN I
No hay otra luz

SECTION I
There Is No Other Light

No hay otra luz

No hay otra luz
Que la que tú imaginas

Recordar
Es vivir de nuevo

There Is No Other Light

There is no other light
Than the one you imagine

To remember
Is to live again

Shiva

Al principio
Fue el asentamiento
Del silencio
El pesar tan hondo
El acontecer tan sombrío

Entonces cubrimos los espejos
Y en el suelo calvo
Te llamamos

Nuestros cuerpos se hicieron inciertos
Embarcaciones errabundas
En las olas de dolor

Después de los siete días
Llegó la luz sobre nuestro rostro
Y sobre el rostro de los espejos

Tu muerte se hizo vida
Emprendimos el aprendizaje
De los recuerdos

Mientras la noche avanzaba
Conversábamos de ti
Y contigo
Repetíamos tus frases
Recordábamos tus temores

Tu muerte logró hacerse dulce
Como tu vida
Una aventura
Una oración al viento

Shiva

In the beginning
Came silence
The sorrow so deep
The ordeal so dark

Then we covered the mirrors
And called your name
On the barren floor

Our bodies became uncertain
Drifting ships
On the waves of pain

Seven days later
Light flowed over our faces
And over the mirrors

Your death became life
We began our apprenticeship
In recollection

And as the night advanced
We spoke of you
With you
We repeated your words
Recalled your fears

Your death became sweet
Like your life
An adventure
A prayer to the wind

Pensando en Santa Teresa

No es verdad que todo pasa
Y que el dolor cede
Tan sólo se aligera
Rezagado
Queda en la cuenca de los ojos
Aletea como una mariposa extraviada

Thinking about Saint Teresa

It is not true that everything passes
And that the pain ceases
It simply grows more weightless
Deferred
It lingers in the hollows of one's eyes
It flutters like an aimless butterfly

Cerca del agua

Cerca del agua
En la arena
Dibujo tu rostro
Que la marea dulcemente borra
Para regresar
A mis manos
Que te sueñan
Y repasan tu vida

Que nada tuyo
Sea olvidado

Cerca del agua
La muerte está cercana
Con sus umbrales sellados
Con la voz que no responde

Near the Water

Near the water
On the sand
I draw your face
Which the sea gently erases
Returning
To my hands
That dream you
And recall your life

May nothing of yours
Be forgotten

Near the water
Death is close by
With its sealed threshold
With a voice that does not respond

Fue dulce tu muerte

Y fue dulce tu muerte
Como un sorbo de agua
Como mirar la dicha
Incomprensible
De un horizonte vasto

Y fue tan dulce tu muerte
Plácido transporte de un sueño
A otro

El aliento de Dios
Cruzó tu piel
Tu piel se hizo
Bosque
Manantial

Fue tan dulce tu muerte
Como un sorbo de agua

Your Death Was Sweet

And your death was sweet
As a sip of water
As the sight
Of incomprehensible joy
On a vast horizon

And your death was so sweet
The peaceful transport from one dream
To another

The breath of God
Crossed your skin
Your skin became
Woods
A spring

And your death was as sweet
As a sip of water

El jardín de Josefina

Cuando anunciaron tu muerte
Las palabras me traicionaron
Se hizo un silencio parco
Salí al jardín
Cavé un círculo sobre la tierra
Del verano

Planté rosas rugosas
Las del océano
Audaces
Que aman la intemperie
El sol despiadado
La nieve terca

Quise que esas rosas
Cubrieran tu jardín
Con la tenacidad de la vida

Después planté una hortensia lila
Tu color favorito que vestía tus sombreros
Para los días de fiesta
Una hortensia que dará sombras
Que crecerá generosa y redonda
Sobre el césped

Alrededor de las rosas rugosas
Planté lavandas
Para que ese perfume

Josefina's Garden

When they announced your death
Words failed me
Left me silent and still
Unable to speak
I went to the garden
And dug a circle in the summer soil

I planted rugosa roses
The bold and hardy ones
Of the oceanside
That like bad weather
The merciless sun
The crusty snow

I wanted those roses
To cover your garden
With the tenacity of life

Then I planted a purple hydrangea
Your favorite color
That graced your hats on holidays
A hydrangea to give shade
Grow fast
Be full and round
On the grass

Around the rugosa roses
I planted lavender
So the perfume

De las cosas tranquilas
Te circundara
Lavandas de Provenza
Lavandas de Irlanda
Lavandas de Chile

También dalias y crisántemos
Porque te gustaban los nombres de las flores
Y muchas veces soñaste con llamarte Dalia

Decidí que necesitabas delfinios
Para que el color lila profundo
Enmarcara tus sueños
Espolvoreara tu vida y tu muerte
Con color a cielo malva
Con un color de mar
Sobre la tierra

Te gustaban las flores salvajes
Las ligeras
Que no pretendían nada más que ser lo que son
Llené tu jardín de cosmos
Naranjas blancos amarillos

Nunca mediste tus palabras
Eras precipitada ante la verdad
Y como un jardín silvestre
Eras profunda y desparramada

Y de pronto dije que necesitabas coriopsis
Flores con nombres latinos
Amarillas dignas poco pretenciosas

Of tranquil things
May surround you
Lavender of Provence
Lavender of Ireland
Lavender of Chile

Also dahlias and chrysanthemums
Because you loved the names of flowers
And dreamed of calling yourself Dahlia

I decided you needed delphiniums
So the deep violet
Can soak your dreams
And dust your life and your death
With color from the mallow sky
With color from the sea
Upon the land

You loved the wild flowers
The weightless ones that aimed
To be nothing more than what they were
I filled your garden with cosmos
Orange and white and yellow

You never measured your words
You rushed headlong towards the truth
And like a wooded garden
You were ever profound
Ever untamed

And suddenly I thought you should have coreopsis
Flowers with Latin names

Ellas darán diáfana paz
A tu jardín
Diurno
Nocturno

Planté claveles rojos
Porque te recordaban a España
Y a los abanicos que calmaban tu corazón

No pude
Abuela
Olvidar las lilas
Las flores que tu marido amaba
Porque eran señoriales
Despedían fragancias ocultas
Evocaban secretas pasiones
Memorias extraviadas

El día de tu muerte
Te hice un jardín
Lo cuido por las mañanas
Converso con tus flores
Les canto
Y de pronto una mariposa
Cobriza como tus cabellos
Me roza los pies

Yellow flowers with dignity
but without pretensions
They will bring your garden
Diaphanous peace
Day and night

I planted red carnations too
They reminded you of Spain
And the fans that calmed your heart

Grandmother
I could not forget
The lilacs
The flowers your husband loved
For being lordly
Exuding dark fragrances
Evoking secret passions and old memories

The day of your death
I made you a garden
I tend it in the morning
I speak with your flowers
I sing to them
And suddenly a butterfly
The color of your coppery hair
Brushes my feet

Rosal

Aquí junto a las costas
Donde el mar oficia sus ceremonias
De alejamientos
Y presencias
He plantado un rosal
Que habita en todas las estaciones
Y florece en todas ellas
Para que tú estés también
Custodiando los bosques

Para que siempre estés
Y tal vez para engañar
A la muerte y sus insinuantes andanzas
He plantado el rosal
Que lleva tu nombre
Josefina
Que recibe a los visitantes
Que tiene voz y memoria
Tal vez consuelo dulce
Tu memoria aquí siempre
Cuando todo se cree perdido
Cuando la muerte juega a derrotarnos

Aquí en las costas de Maine
Entre el paso de las nieblas
Y la voz de la noche que resuena como una campana clara
Josefina la rosa rugosa
Celebra el paso de las estaciones
Enseña a conversar con los muertos

Rosebush

Here on the coast
Where the sea
Conducts ceremonies
Of departures and returns
I planted a rosebush
That thrives
And blooms
Throughout the year
Now you too
Watch over the forests

To keep you alive
To cheat death and its insinuating tricks
I planted the rosebush
That carries your name
Josefina
That receives callers
And has voice and memory
Sweet consolation perhaps
Your memory is here forever
When we think all may be lost
When death endeavors to defeat us

Here on Maine's coast
Between the scudding clouds
And the night that resounds like a bell
Josefina the rugosa rose
Celebrates the seasons
And shows us how
To converse with the dead

Dicen

Dicen que estás al lado del Santo Padre
Y que el altísimo te protege

Solías decir que ni el Dios de los judíos
Ni el de los cristianos
Entendía las peripecias de la vida
O los percances de la muerte

Pero si hay un cielo
Estarás sentada con abanicos de papiro
Tendrás un cetro luminoso
Y presidirás
Como una soberana justa
Sobre tus dominios

Le pedirás a los ángeles
Que te traigan pasteles
Y tu vermouth
Para endulzar la noche

Abuela
Tú sabías que el paraíso era la tierra
Y ahora
En el cielo
También celebras

They Say

They say you're at the side of the heavenly father
And that the almighty protects you

You used to tell me that neither the god of the Jews
Nor the god of the Christians
Understood the vicissitudes of life
Or the mishaps of death

But if there is a heaven
You are seated with papyrus fans
You have a shining scepter
And like a just sovereign
You preside
Over your domain

You ask the angels
To bring you pastries
And your vermouth
To sweeten the night

Grandmother
You knew that paradise was here on earth
And now
In heaven
You are celebrating again

SECCIÓN II
Deshaciendo una vida

SECTION II
Undoing a Life

Deshaciendo una vida

Mamá

Regresas para deshacer una vida
Vacilas por dónde empezar
También tú has perdido la cordura
El dolor es una mortaja de bosques calcinados
Que te rodea

Revisas cartas abandonadas
De parajes desolados
Recibos de las compras matutinas
Conoces a tu madre
A través de las huellas
Escombros de una vida
Diminutos papeles regados

Guardas
Las fotografías que preservan la falsedad del tiempo ido
Su peineta de nácar
La camisa de dormir que protegía su cuerpo de niña vieja
El lápiz labial que enmarcaba el labio seco y dormido

Deshaces una vida
Preguntas quién deshacerá la tuya
Cierras el portal
Donde ella habitó
Y contempló ingenua el pasar de los días

Undoing a Life

Mother

You return to undo a life
You hesitate about where to start
You too have lost your balance
And the pain is a shroud of charred forests
That surrounds you

You reread abandoned letters
From desolate places
Receipts of purchases
You know your mother
By the traces
The remains of a life
Bits of paper strewn about

You save
The photographs that preserve the illusory time gone by
The mother-of-pearl comb
The nightgown that warmed the aging body of a child
The lipstick that lined the dry and dormant lip

You undo a life
You ask who will undo yours
You close the door behind you
Where she lived
And mourn time's passing

Tú ya nada deseas
Ni nada reconoces
Como una hija obediente
Ordenas su vida
Botas papeles
Vestidos de estaciones muertas
Colonias a medio usar

Y no regresarás a la casa
Eres huérfana
Navegando a solas
Temerosa
Sales a la intemperie
Con el chal de tu madre
Que amengua los escalofríos de la muerte

You want nothing
Recognize nothing
Like an obedient daughter
You put her life in order
Shoes papers
Dresses from seasons now dead
Half-empty bottles of perfume

You can no longer go home
You are now an orphan
Adrift
Frightened
You come outside
Wearing your mother's shawl
To ward off death's chill

Kadish

Mamá

En septiembre
La voz sonora de la tierra
Se desliza
Nos preparamos como
Cada septiembre
Para este día
Yom Kipur
Con sus letanías
Como un dulce agobio
El día en que nos pedimos
Perdón entre nosotros
Y Dios ausente responde
En su habitual silencio sagrado

Esta vez eres tú
La que canta el *Kadish*
El rezo en arameo quema
Tu lengua agobiada por el dolor
Trastornador de la muerte

Rezas por ella
Y por ti
Tiemblas por las dudas
No sabes si fuiste demasiado obediente
Demasiado distante
Y te la imaginas a ella
Tu madre

Kaddish

Mother

In September
The rumbling voice of the earth
Is heard
We prepare ourselves
As we do each September
To honor this day
Yom Kippur
Its litanies
Weighing sweetly upon us
A day when we forgive each other
And when an absent God
Responds in his habitual sacred silence

This time you are the one
Who sings the *Kaddish*
The Aramaic prayer burns
And curls your tongue
With death's pain

You pray for her
And for yourself
You tremble with doubts
Were you too obedient
Too distant
You imagine her
Your mother

En los mares del sur
Deshabitada
Sola
Como la niebla que acecha a su ciudad deshabitada

Sollozas
Tus manos son abanicos caídos
Tiemblas
El *sidur* se resbala de tus manos
Como si éste reconociera que tampoco eres
Obediente ante la fe

El rezo avanza
La melodía desgarra
La melodía conjura a los vivos
La tierra es una grieta olvidada

No te tomo las manos
No te beso
Te dejo que estés entre las sombras
Y en el extraordinario silencio de este día
De esta noche alargada
Silencio como la inoportuna
Llegada de la muerte

Algún día seré yo
La que ocupa tu silla
El *Kadish* quemará mis labios
El antiguo rezo en arameo caerá
Como un gemido en mi cuerpo

On the seas of the south
Abandoned
Alone
Like the fog that watches over her city

You weep
Your hands are folded fans
You quake
The *siddur* slips from your fingers
As if recognizing
That you are not obedient in faith
Either

The prayer rumbles on
The melody rips apart and binds together the living
Opens an oval crack in the earth

I do not hold your hands
I do not kiss you
I leave you in the shadows
In the stunning silence of this day
Of this long night
Silence like the inopportune arrival
Of death

Someday I will be the one
Who occupies your seat
The *Kaddish* will burn my lips
The ancient prayer in Aramaic will issue
Like a wail from my body

Y nadie me tomará de las manos
Ni me dará un beso en la mejilla
Mi hija también me dejará sola
Comulgando entre las sombras
Rezando por tu paz
Como ahora lo haces por la
De tu madre

Y en este día extraordinario
Desolado
Una antigua ternura
Nos adormece
Alguien enciende una vela
Y nos llama por nuestro nombre

And nobody will take my hand
Or kiss me on the cheek
My daughter will leave me alone then too
Communing with the shadows
Praying for peace for you
As you now pray for peace
For your mother

And on this extraordinarily desolate day
An ancient tenderness
Puts us to sleep
Someone lights a candle
And calls our name

Tú regresas

Mamá

Regresas ligera de equipaje
Nadie te reconoce
Los que quedan
Conversan con los muertos

La casa de tu madre
A nadie vigila
Nadie se preocupa
Por tus andanzas
Nadie adivina la ilusión
De tus regresos

Has vuelto al país de los muertos
A la soberanía de la ausencia
Las mesas vacías
Las sillas mancas
Las fiestas entre los que sólo rememoran
Para que ellos tampoco se olviden

Y sin embargo regresas
Encuentras consuelo en que alguien
A lo lejos te haga señas
Y no sabes ni preguntas
Si es él del reino de los vivos
O de los muertos

You Return

Mother

You return light of baggage
Nobody knows you
Those who remain
Converse with the dead alone

Nobody watches
Your mother's house
Nobody worries about
What has happened to you
Nobody guesses
The hopes you cherished
For your return

You have gone back
To the country of the dead
Where absence reigns
Empty tables
Armless chairs
Festivals held only
To remember the dead

Yet you return
And find solace
When someone beckons from afar
Whether from the realm of the living
Or of the dead
You know not

Has aprendido
A rendir espacios a los silencios
A vivir entre una marejada de dudas
La ambigüedad te cobija
Le sonríes
Regresas

You have learned
To give space to silences
To live in a sea of doubt
Wrapped in ambiguity
You smile
You return

Domingos

Todos los domingos
A mediodía
Mi madre llamaba a
Su madre
Ceremoniosas
Se trataban de usted
Intercambiaban con cautela
Noticias familiares
Hablaban del estado del tiempo
En la América del Norte

Una contaba
La otra preguntaba
Mientras la lejanía de la voz
Dejaba un surco muy leve
Grietas sinuosas
Y las voces se hacían
Irreconocibles
En la lejanía de los años
Que trastornan la piel y el amor
Poco a poco
Tan sólo mi madre hablaba
Los domingos
Y su madre
Sonreía
Divagaba
O escuchaba los sonidos que
Su memoria dibujaba
A veces emitía

Sundays

Every Sunday
At noon
My mother called
Her mother
They exchanged family news
Ceremoniously
Formally
Cautiously
They discussed the weather
In North America

One recounted
The other questioned
While the distance between the voices
Wrought its furrows
Its sinuous cracks
And rendered the voices strange
Across the span of years
That ravage flesh and love
Gradually
Only my mother
Did the talking
On Sundays
And her mother
Smiled
Rambled on
Or listened to the sounds
That awakened memories
At times she would sigh

Sonidos
Murmullos
Pero era una voz extraviada
Como la arena después de las mareas altas

Un domingo
Mi madre dejó de llamar
Su madre ya no estaba
Y el teléfono
Yacía también muerto
Y a pedazos

Ya no habrán más domingos
Para repetir las ceremonias
Del amor o del desamor
Ni para intercambiar saludos
Ni para pedirse perdón
Ni para preguntar todo lo que no se pudo

Los domingos al mediodía
Mi madre
Acaricia a las piedras

But her voice would drift
Like the sand
After high tide

One Sunday
My mother did not call
Her mother was no longer there
And the telephone
Was dead as well
Broken

There will be no more Sundays
For such ceremonies
To express love or anger
To exchange greetings
To beg forgiveness
To ask about all
That could not be

Sundays at noon
My mother
Caresses the stones

Tu voz

Más allá de tu voz
Y su clara cadencia
Hay una historia
Silencio petrificado por un enigma
Más allá de tu voz
Hay la memoria de otra voz
En un idioma clausurado
En una historia negada

Te imagino peinando tus palabras
Para bendecir para maldecir en Yidish
O tal vez recordar a tu padre
En una esquina cabizbaja
En un pueblo extraviado de los mapas
Cantando un lamento
La fe de una historia enmudecida

Pero tu voz
Era el español
Castellano ladino
Ese castellano que tú amabas
Afilado salvaje veloz
Ese idioma que no ocultaba nada
Que te ayudó a decirlo todo
Ese castellano que florece en tu exilio

Este otoño rememoro
La prontitud de tu muerte

Your Voice

Beyond your voice
And its clear cadence
Is a history
A silence petrified by enigma
Beyond your voice
Is a remembered voice
Another voice
Of a cloistered language
And a buried history

I imagine you combing your words
To bless or curse in Yiddish
Or recall your father
Head bowed on a street corner
In a town stricken from the maps
His song a lament
Reverence for a silenced history

But your voice
Was Spanish
Español Castilian Ladino
The Spanish you loved
Incisive primitive rapid
That hid nothing
That let you say it all
The Spanish that blossoms in your exile

This autumn
I recall your sudden death

Que ha despoblado mi historia
Sin tu voz
Quedo cual hoja desprendida
Y perdida
En el exilio que es la muerte
Me imagino tus dichos
Tus manías
Tus secretos

Pero no es sólo la voz del castellano
Que escucho en la memoria alucinada
Por los espectros
Es la voz del Yidish
Que se reconoce entre los escombros
Entre los testimonios cubiertos
O tal vez el hebreo
Que te atemorizaba
Por los rezos
Y la ausencia de Dios en tu peregrinar

Y aunque nunca me hablaste de esos idiomas
Porque les temías a los fantasmas
Y a dormir cautiva entre los umbrales
Después de tu muerte
Es tan sólo esa voz que oigo
Huella de otras herencias

Which has ravaged my life
Your voice is gone
I am alone
I am like a fallen leaf
Lost in an exile that too is death
I imagine your sayings
Your eccentricities
Your secrets

But in my hallucinating haunted memory
It is not only your voice in Spanish I hear
It is also the voice of Yiddish
Discernible in the rubble
In the covert testimonies
Or perhaps the voice of Hebrew
Which frightened you
Because you feared the prayers
And the absence of God
In your pilgrimage

And while you never spoke in those languages
Because you were afraid of their ghosts
Afraid of being captured
While asleep in a doorway
After your death
It is that voice I hear
The voice that reveals traces
Of your heritage

Las ceremonias del adiós

No te gustaban las despedidas
Ninguna palabra aligeraba
Las ceremonias del adiós
Chao te decía
Hasta pronto mi vida
Adiós Josefina
Adiós
Y te hacía señas
Mientras tus ojos tan azules
Como ese océano Pacífico que enmarcaba tu ciudad
Me miraban desde una lejanía habitada
Por las ilusiones precarias
Siempre temías los adioses

Imposible imaginar la vida sin ti
Sin tus manos frente al balcón
Contando mis idas y venidas
Planeando regresos
Recibiendo cartas
Cuando yo también soñaba
Con verte frente al balcón
Tus manos ansiosas
Trenzadas
Como una *Jala*

Ahora regreso
Nadie espera en el balcón
Visito tu tumba
Donde no estás

The Ceremonies of Good-bye

You never liked good-byes
No word could make the forms of good-bye
Bearable for you
Ciao I said
Till soon my love
Good-bye Josefina
Good-bye
And I waved farewell
While with your blue eyes
Blue as the Pacific that frames your city
You watched me from a distance
Filled with fragile hope
You always feared good-byes

I cannot imagine life without you
Your hand clasping the balcony
Counting my comings and goings
Planning my returns
Receiving my letters
While I dreamed
Of seeing you at the balcony
With your fretting hands
Intertwined
Like a *Challah*

Now I return
No one waits on the balcony
I visit your grave
Where you are not

Rezo a un Dios extraño
Para ti
No escribo cartas
El dolor me ahorca
Susurro tu nombre

Y en esa palabra
Que te llama
Brota la fe
Apacigua la incertidumbre
De tu partida
De tu llegada

Ahora a nada temo
Ni tampoco a los adioses
Todo se vuelve en un
Hasta siempre

I pray to a foreign god
For you
I write no more letters
I feel strangled by pain
I whisper your name

And in that word
Which evokes you
Faith blossoms
Assuages the uncertainty
Of your departure
Of your arrival

Now I fear nothing
Not even good-byes
Everything becomes
Until forever

Para prolongar tu vida

Para prolongar tu vida
Reposan tus objetos amados
Sobre esa mesa lacia
El cepillo de nácar
El espejo de malaquita
La peineta de caoba
El vaso de agua
Que curaba tu sed
Que guardaba tu dentadura risueña
Los contemplo
Me siento cada vez más pequeña
Ante este universo de cosas perdidas
De adioses oportunos e inoportunos

Para prolongar tu vida
Te escribo cartas
Pero no te cuento de ningún triunfo
Tan sólo de las puestas del sol
De las estrellas del mar
De la mano de Sonia
De los amores de Joseph
Y luego te beso

To Extend Your Life

To extend your life
I lay out your favorite articles
On the lifeless table
The mother-of-pearl brush
The malachite mirror
The mahogany comb
The water glass
That satisfied your thirst
That held your smiling dentures
I gaze at these objects
Feeling smaller and smaller
In this universe of things lost
Of timely and untimely good-byes

To extend your life
I write letters to you
But tell you not of successes
Only of the setting sun
Of the stars of the sea
Of Sonia's hand
Of Joseph's loves
And then I kiss you

La coleccionista

Los vivos
Ordenaron tus pertenencias
Atemorizados entraron a las zonas
Del recuerdo
Decidieron qué hacer con tu sombrero
Favorito
El de paja violeta
El que te protegía del sol
Que lamía las carencias de tu piel

Cautelosos disciplinados
Fueron ordenando tu vida
Nada quedó al azar
O a la deriva
Todo en ti era azar
Deriva
Instante

Tus hermanas se llevaron los abrigos
Tu hija una pintura que tú solías mirar
Los vecinos pidieron
Intermitentemente lejanamente
Las ollas carcomidas

Cuando me ofrecieron a mí
Alguna de tus pertenencias
Supe que no eras coleccionista
Que tal vez sin saberlo
Fuiste una lepidóptera

The Collector

The living
Put your belongings in order
They entered zones
Of memory
Timidly
Decided what to do with your favorite hat
The lavender one of straw
That protected you from the sun
That absorbed your perspiration

With discipline and caution
They put your life in order
Left nothing to chance
To drift
But everything about you was chance
Adrift
Spontaneous

Your sisters took your coats
Your daughter the painting you loved
The neighbors hesitantly
From a distance
Requested the cracked kettles

They asked me
What I might want
I knew you were not a collector
Though maybe unknowingly

Que amabas las mariposas cobrizas
Que le temías a las monarcas
Te gustaba tan sólo guardar el sabor del café
Del mediodía
te gustaba guardar lo imposible
Una rosa que perdía los detalles
En el momento de ser

De ti tan sólo pedí
Las señas de tu identidad
Tu carnet con las huellas digitales
Para saber que no fuiste una transeúnte sobre la tierra
Que eras una amadora triunfadora de las cosas efímeras
De lo intangible
Que te gustaba inventar el final de las películas
Y de los sueños

Cuando decidieron cerrar la casa
Darle fin a tu vida
A tu morada
Yo supe que estabas espiándolos
En el café de la esquina
Con tu cintura arqueada
Sobre la tierra
Como si bailaras
Con tu risa
Lluviosa y plena

Sé que coleccionabas tan sólo
Los instantes
Lo inconmensurable
La vida

A lepidopterist
For you loved the copper-colored butterflies
And feared the Monarchs
You savored the smell of coffee
At midday
You always wished to save the evanescent
A rose losing its petals
At the peak of its bloom

Of your belongings I wanted
Only the evidence of who you were
Such as your identity card with your fingerprints
To know you were not a transient on this earth
But rather a victorious lover
Of things intangible ephemeral
Fond of inventing new endings for movies
And dreams

When they finally sealed the house
Your dwelling
And gave closure to your life
I knew you were watching
From the corner café
Stooped over
As if dancing
And laughing
Heartily

I know you collected only
The fleeting moments
The immeasurable
True life

Regresos

Imagino que
Me esperarás
En todos mis regresos
Estarás con gladiolos
Rojizos
Tu verdadero cetro
Cobijando las puertas
De la tierra
La entrada a Chile
Y cruzarás los Andes
Junto a mis ojos

Al llegar
El viento será
Como ese chal que
Que aguardaba por mí
Y aprenderé a reconocerte
En cada ausencia
En cada señal que
Presagie tu vida

Estás
Como el aliento de Dios
Sobre los céspedes

Returns

I imagine
You will wait for me
Whenever I return
You will greet me
With red gladiolus
Your true scepter
Guarding the gates
Of the land
The entrance to Chile
And you will cross the Andes
With my eyes

When I arrive
The wind will be
Like the shawl
You saved for me
And I will learn to recognize you
In every absence
In every sign
That portends your life

You are there
Like God's breath
Over the grass

Aprendí a jugar

Aprendí a jugar con tu rostro
Con tus anteojos
Matizados por tu pelo
Te imaginaba mariposa cobriza
Leopardo dorado
Navegando entre los días
Siempre a la intemperie
Descubierta y plena

En la vejez
También me seducía
Imaginarte lentamente
Sentir las hendiduras
Pequeños fragmentos
De estrellas extraviadas
Ríos nocturnos
Que por la noche iban hasta la deriva
De todos los sueños

Te sentía pequeña
Entre el tiempo que no es tiempo
Tus palabras
Reposadas
Como el rezo de los magos
O las sacerdotisas
Enamoradas

En tus últimos días
Recorrí tu frente

I Learned to Play

I learned to play with your face
With your glasses
Tinted to match your hair
I imagined you as a coppery butterfly
A golden leopard
Navigating through days
Of bad weather
Vulnerable but confident

In old age
You once again seduced
My imagination
I explored
The lines of your face
Minute trails of wayward stars
Meandering rivers
Through night's dreams

I saw you as tiny
Between timelessness and time
Your words
Brought peace
Like the prayers
Of magicians
And loving priests

In your final days
I touched your forehead

Intenté descifrar los signos
Del paraíso en la tierra
El rictus de tu boca
Tan sólo encontré una risa melodiosa

Ahora más allá de tu muerte
Tu rostro entre los espejos
Danzando como cascada entre mis manos
Siempre tu rostro
Abierto
Incomparable
Libro sagrado de tus días

To decipher the signs
Of paradise on earth
I traced your mouth
And found sweet melodious laughter

Now beyond death
Your face appears in the mirrors
Dancing
Cascading through my hands
Your ingenuous face
Unique
Is a sacred book of your days

Pertenencias

De todas tus pertenencias
Pedí el chal bondadoso
Que cubría tu espalda arqueada
Que poblaba tus noches y tus abismos
Con ternura

Quise sentir las lanas sobre
Mi piel
Que huele a la tuya
Que te rememora

El chal arqueado y sinuoso
Guardó el reflejo de tu cuerpo
Se hizo rostro
Color
Aliento

Me gusta envolverme en él
Imaginarme que eres tú
Quien me toma de las manos
Para cerciorarse que no tendré frío
En este invierno
Cuando la lluvia se posa en las ventanas carcomidas
Y que no pasaré más tristezas
Ni de amor ni de soledades

No te has ido del todo
Vives conmigo
Te nombro

Belongings

Of all your belongings
I asked only for the shawl
That cloaked your bent shoulders
With love
That softened your nights and your sorrows
With tenderness

I wished to feel the wool
On my skin
Which now bears your scent
Which recalls you

The sinuously curved shawl
Reflected your body
Became your countenance
Your color your breath

I like to wrap myself in the shawl
Imagining that it is you
Who takes my hands
To make sure I'm not cold
This winter
When rain pools on old windowsills
And that I won't suffer again
From loneliness or love

You have not really left
You live with me
I call your name

Y te pregunto cosas

Y al pensarte
Llega el día como una ráfaga
Como la esperanza de haber vivido
Y vives ahora en mi lengua
Que te llama
Que te teje
Como las lanas que tú
Cuando fui niña
Me obsequiaste
Para contar historias

I ask you questions

And when I think of you
The day comes like a gust of wind
Like the hope that you have lived
And live now
In my speech
That evokes you
Weaves you
Like the wool cloth you gave me
When I was a child
To tell stories

Palpar una lejanía

Y el exilio fue
Palpar una lejanía
Sentirse huérfana
De aire
De tiempos
Que se comparten
Siempre desde lejos

Esa lejanía
Cavó grietas
Pozos de duda
Imaginamos regresos
Parques fuentes bicicletas
Dormidas

Y el exilio
Separó generaciones
Negó la posibilidad de
Celebrar la vida
Acompañar a la hora de la muerte

Empezamos los del exilio
A cambiar nuestra voz
Nuestras palabras
Como las cortezas del árbol
Que se desprenden con la soledad
De lo irreparable
De una intemperie honda

To Feel a Distance

And exile meant
Suffering a distance
Being an orphan
Of the air
Of the times
Sharing only from afar

That distance
Bore deep holes
Wells of doubt
We imagined our return
Parks fountains bicycles
All asleep

And exile
Split generations
Precluded our celebration of life
Our presence at the hour of death

In exile
We began to change
Our speech
Our words
We were like the bark of a tree
Broken off
In the loneliness
Of a storm

Vivimos
El pasar de los días
Las noches cautivas
En casas vacías
Con pocos invitados
Mientras imaginábamos
A los que se quedaron atrás

Y cuando por fin
Se hizo posible el regreso
No quedaba nadie
Más que los muertos
Aguardando

We lived
Passed the days and nights
Captive in empty houses
With few guests
Envisaging
Those who had stayed behind

And finally
When we were able to return
We found no one there
But the dead
Watching

No quise censurar

No quise censurar
La imagen del adiós
En un ataúd insomniado
Bajando las frágiles escaleras
Escaleras que no sueñan con
Los ángeles de Jacobo

Algo me impidió llegar al entierro
Ver los parientes lejanos
Jurar amor eterno
Y alabar a los muertos
El dicho dice que todos
Los muertos son buenos

En cambio te recuerdo
Traviesa
Alegando en voz alta
Por el alza del arroz
Deseosa de ir a un café
En tu carromato de lujo
Una silla de ruedas de segunda mano
Besándome los dedos
Contándome de tus viajes
Que vivías en cada recuerdo

Si me es permitida una última imagen
De tu vida concedo ésta
Viña del Mar
Un vaso de champaña importada

I Did Not Want to Criticize

I will not criticize
The image of your departure
In a sleepless casket
Carried down decrepit stairs
Stairs that don't dream
Of Jacob's ladder

Something prevented my attending the burial
Seeing our distant relatives
Swearing eternal love
And praising the dead
All dead people are good people
The saying goes

Instead I'll remember you
As mischievous
Contending loudly over the price of rice
Eager to go to a café
In your second-hand wheelchair
Your chariot
Kissing my fingers
Recounting tales of your travels
Which you relive in each telling

If I may have a final image
Of your life
It would be December 31st
Viña del Mar
A glass of imported champagne

Una mano entre temblorosa y firme
Brindando por más de media hora
Diciendo
Gracias gracias a la vida

Salud
L'Jaim

A hand at once tremulous and sure
Offering toasts for half an hour
Giving thanks and more thanks
For life

Cheers
L'Chaim

Paisajes

Despojados de tu voz y de tu presencia
Entran a tu paisaje de anciana niña muerta
Y como extranjeros a lo que fue tu vida
Revisan tus pertenencias
Se deshacen de los objetos queridos
Un abanico de Sevilla
Una taza quebradiza y frágil
Donde bebías el solitario té
De todas las tardes

Deshojan tus papeles
Los recortes de diarios
De familiares
Queridos y despreciados
Igual los querías
Y guardabas en las gavetas de importancia
Sus historias

Se pasean por tu casa que
Ya no es la tuya

Nada se posee después
De la muerte

Landscapes

Deprived of your voice and your presence
They invade the landscape
That belonged to you
An old lady with a child's heart
Strangers to what your life was
They rearrange your belongings
Take down beloved objects
The fan from Seville
The fragile cracked cup
Which held the tea you drank alone
In the afternoon

They destroy your papers
Newspaper clippings
About family and friends
Unappreciated by the world
But loved by you
Whose stories you saved
Where you kept your things
Of importance

They stroll through the house
That is no longer yours

After death one owns nothing

SECCIÓN III
Canto

SECTION III
Song

Canto

Cuando niña me esperabas
En las esquinas
Dejaba mi mochila en
Tus rodillas
Te contaba cuentos
Tú inventabas otros
Y cantábamos

Song

When I was a child
You waited for me
On the corner
I dropped my book bag
On your lap
I told you stories
You invented others
And we sang

Camisas de dormir

Yacen tus camisas
A los pies de la cama
Las de raso azul que te
Recordaban trozos del cielo
La negra que usaste el día en que
Te casaste y temiste el secreto
De tu propio cuerpo

El día de tu muerte
Otras mujeres lavaron tu cuerpo
Lo hicieron con ternura
Te dejaron como eres
Clara bella silenciosa
Ante el reposo
Te cubrieron con una sábana blanca
Mientras las camisas que antes vestían tu cuerpo
Reposaban y lloraban

Tan sólo tú y la sábana blanca
Tan sólo el cuerpo vestido en el alma
O el alma en un cofre blanco
La muerte se apiadó ante tu belleza

Te imaginé deseando levantarte
Negar a la muerte
Y al destino pero
Esa sábana blanca
Te mecía

Nightgowns

Your nightgowns lie
At the foot of the bed
The blue satin ones
That recalled patches of sky
The black one you wore
The day you wed
Afraid to reveal your body's secret

The day of your death
Women bathed your body
Tenderly
They left you as you are
Pale silent pretty
At rest
They cloaked you with a white sheet
While the nightgowns that once clothed
Your body lay still
Mourning

Now there is only you and the white sheet
Only your body dressed in its soul
The soul in a white casket
Death was moved to pity before your beauty

I imagined you wishing to rise up
Deny death
And destiny
But that white sheet
Held you

Te acomodaste a la tierra
Y a sus cortezas
Con la misma diáfana ilusión que acomodaste
Tu cuerpo a la vida

You were adapting
To the rough earth
With the same sheer joy
With which your body adapted to life

Tu bondad

Tu bondad
La confundían
Con una inocencia
Senil
Tu verdad
Con cosas de señoras excéntricas

Pocos sabían que estabas
Más allá del
Ritual del buen comportamiento
Que tus pensamientos más íntimos
Los compartías en voz alta
Que no sabías ocultar
Ni la mentira
Ni las falsedades
Que te gustaba ser sorda
Para no oír falsedades
Y que en los tiempos de la ceguera
Siempre seguiste viendo con
El corazón

Your Goodness

They confused
Your goodness
With senile innocence
Your truth
With elderly eccentricities

Few knew
That you were beyond
Conventions of good behavior
That you spoke aloud
Your most intimate thoughts
That you could not lie
Or deceive
That you liked being deaf
Unable to hear untruths
And that when you grew blind
You could still see
With your heart

Cepillo de nácar

Aquí yace tu cepillo de nácar
Traído de Italia
Soñadora llena de fuentes
Y arcángeles

Junto al espejo cubierto
Para ahuyentar el rostro
Trizado que divulga
Tu ausencia
El cepillo de nácar
Cobija tus cabellos

Por años te los cepilló
Como fiel cómplice de tu belleza
De tus cabellos rojizos
Que parecían ser cascadas
Tempestad de vida sobre tus hombros

Ahora encuentro sedimentos grises
Alquimia del pasado y del ahora
También pasado

El cepillo divulga tus secretos
El pasar de los años en dicha
Y en olvido
El pelo desafiador
Y el humilde que se cae
De la nuca
Que se adelgaza
Como fueron tus días

Mother-of-Pearl Brush

Here sits your brush of mother-of-pearl
Brought from Italy
Dreamland of fountains
And archangels

Next to the mirror
That is shrouded
To banish the face
And signal your absence
The brush of mother-of-pearl
Safeguards your hair

It brushed your hair for years
Like an accomplice to your beauty
The red hair
That flowed across your shoulders
Like a tempestuous cascade of life

Now I find gray sediment
Alchemy of the past and the present
That too is gone

The brush divulges your secrets
The passing of the years in happiness
In oblivion
The hair defiant
And humble
Falling freely down your neck
Thinning
Like your days

Me acerco a él
Y le pregunto por ti
Los objetos de los muertos responden
Hay que hablarles con paciencia
Sin premuras

El cepillo de nácar
Se acerca a mis manos
Me devuelve tu fragancia
El espejo se desnuda de tu mortaja
Yo me cepillo mis cabellos
También rojizos
También grises que se adelgazan
Con tu ausencia
Como un cristal visionario

Nos repetimos los gestos
Soy tú
Tú eres lo que fui y lo que seré

Tomo en mis manos
Ramitos de tus cabellos
Flores nocturnas
Amarradas y cautelosas
Las dejo volar
Se deslizan por el cuarto
Pequeñas bujías
Pequeñas luciérnagas

El cepillo de nácar
El espejo
La peineta de caoba

I ask it
About you
The possessions of the dead speak to us
One has to communicate with patience
Without haste

The brush of mother-of-pearl
Falls into my hands
Renders your scent
The mirror sheds its shroud
I brush my hair
Red like yours
Gray like yours and thinning
With your absence

As in a crystal ball
We see our faces again and again
I am you
You are what I was and what I will be

I take in my fingers
Strands of your hair
Nocturnal flowers
Bound together
I let them fly
They float through the room
Little candles
Little fireflies

The brush of mother-of-pearl
The mirror
The comb of mahogany

Tus más íntimos amigos
Rememoran el fulgor de tus días
Y el recato de tu muerte

Tu cabello vive en el mío
Acaricio un mechón gris
Que sobrevivió a tu muerte
Crece
Es una raíz soberana
Se desplaza por mis manos
Sube a mi cuello
Y se arraiga a todas las cosas
Vivas
Como sigue siendo tu vida
En un ahora siempre presente
En un nombre que siempre te nombra

Cruza el viento por tu cuarto vacío
El cepillo de nácar
Gira sobre la luz
El ángel de la memoria
Corona tus cabellos

Your most intimate friends
Recall the radiance of your days
And the humility of your death

Your hair lives in mine
I caress a gray lock
That survived your death
Let it grow
As a source of power
It leaves my hands
Falls across my neck
And becomes part of my own
Now you may live
As if going on with your life
In a now that is always present
In a name that was always yours

The wind blows through your vacant room
And the brush of mother-of-pearl
Reflects the light
The angel of memory
Crowns your hair

Los espejos

En los días
De muerte
Cubrías los espejos
Con tules magentas
Que el rostro no conozca
La fisonomía de la muerte

Mirrors

On the days
Of death
You covered the mirrors
With magenta tulle
So you would not know
The face of death

Tu elegancia

Tu elegancia
No era
Ni de los nobles
Ni de los plebeyos
Tan sólo tuya
Elegancia alada
Elegancia de un ángel travieso
Casi invisible
Casi de tules y vahos
Pero no obstante
Elegancia
En la mesura del decir
Y del no decir

Tu riqueza no era
La de las joyas antiguas
O la de la coleccionista de
Baratillos
Tan sólo en tu
Contemplar
En tu reír
En una grandeza diminuta
Y grandiosa

Nos gustaba verte
Pasar
Radiante ligera
Como un origen
Amanecer claro
Con los resquicios
Del sol
El viento inclinándose
Al verte pasar

Your Elegance

Your elegance
Was not that of nobles
Nor that of plebeians
It was uniquely yours
A winged elegance
The elegance
Of an almost invisible
Mischievous angel
Made of tulle and mist
But elegance
Nonetheless
Spoken
And unspoken

Your wealth
Lay not in antique jewels
Or in collections of trinkets
But in your thoughts
In your laughter
In a diminutive and magnificent grandeur

We loved to see you
Pass by
Lightly radiant
Like an origin
Like a luminescent dawn
The glimmer of sunshine
The wind bowing
In honor of you

Entre tus pasiones

Entre tus pasiones
Los libros
Los folletines
Las revistas de moda
Los romances
Los poemas de amor
Las historias de la realeza europea
Los libros sobre las victorias inverosímiles
La Biblia de vez en cuando
Los periódicos con noticias truculentas
Jamás las recetas de cocina

La lectura era delicia perfumada
Y perfumada te inclinabas para
Ser mesurada y desmesurada en el
Oficio de la lectura
Para entender a un prójimo desconocido
O una enloquecida novia buscando al novio
Extraviado

Entre las páginas
Más allá de todas las historias
Podías ser beduina
Peregrina
Dueña de un restaurante
Hechicera

Entre las tardes claras y oscuras
Leías en voz alta

Among Your Passions

Among your passions were
Books
Serials
Fashion magazines
Romances
Poems of love
Histories of European royalty
Accounts of improbable triumphs
Occasionally the Bible
And scandalous news
Never recipes for cooking

Reading held the pleasure of perfume
For you
And perfumed you were
At rest in your armchair
In flight in your mind
You read to understand a mysterious neighbor
Or a crazy bride in search of a wayward groom

Between the pages
Beyond all the stories
You could be a Bedouin
A pilgrim
A restaurateur
A sorceress

Through afternoons sunny and cloudy
You read aloud

Rememorabas ciudades reales e imaginarias
Eras asidua en los detalles
Amabas los libros imperfectos
De lomos vencidos
En ellos encontrabas
Historias de valor
En ellos reposabas tu frente húmeda

Cada alfabeto era júbilo
Instante de gloria
Los pequeños delirios de todos
Los días

Con el pasar de los tiempos frágiles
Tus libros quedaron solos
Algunos vagaron desde tu sofá
A las manos de otros lectores
Menos ávidos que tú
Pero igual fueron capaces de alcanzar sus destinos
Nada de aquella biblioteca victoriosa quedó
Abuela
Tan sólo el recuerdo de ella
Las palabras que de ti emanaban cuando
Me hablabas de tus libros dispersos por el mundo

Y yo recogía tus palabras
Hacía de ellas collares
Cuadernos abiertos
Y te obsequiaba tus cuentos

Recreating cities real and imaginary
Absorbed in the details
You loved the imperfect books
With broken spines
In them you found
Stories of valor
On them you rested your damp forehead

Each letter brought joy
A moment of glory
Some small bliss
For the day

With the passage of time
Your books were left alone
Some strayed from your sofa
To hands of other readers
Less avid than you
But like you
Capable of achieving dreams
Through reading
Grandmother
Nothing of your victorious library remains
Only the memory
And the words that emanated from you
When you spoke to me of your books
Scattered across the world

And I have reclaimed your words
Made them into necklaces
and notebooks
To give you back your stories

Ahora en tu cuarto vacío
El sillón también vacila
Sin tu cuerpo
Sin un libro que era
Un almanaque de sueños
Un obsequio transparente
Para tus dedos de hojas
Luminosas

Your room is now empty
Your chair rocks without your body
Without a book
To be your almanac of dreams
Transparent gift
Of luminous pages
For your fingers

Los pisos de arena

Mi abuelo y yo
Disputábamos
Sobre el lugar
De las mujeres
En la sinagoga
Y el por qué esa cortina
Oscurecida
Nos dividía
Quería yo rezar a su lado
Sentir su aliento mientras
Cantaba las letras hebreas que
Para mí parecían un mosaico
De trenzas antiguas

Cuando me hice mayor
Dejé de rezar junto a los otros
Elegía un amanecer
Una noche
Después de leer un poema
O hacer el amor
Dios llegaba hacia mí
Reposado
Resuelto a no abandonarme
Porque era
Plena en mi fe

Me sentía dichosa de discutir con
Dios
De preguntarle por sus direcciones

Floors of Sand

My grandfather and I
Would argue
Over the place
Of women
In the synagogue
And over the reason the dark curtain
Kept us apart
I wanted to pray at his side
Feel his breath
While I sang the Hebrew letters
That seemed a mosaic
Of ancient braids

When I got older
I no longer prayed
Near others
I chose daybreak
Or night
After reading a poem
Or making love
God would approach me
Quietly then
Resolved not to abandon me
Because I was
Full of faith

I took pleasure in arguing with
God
Questioning his direction

Por la falta de respuesta a mis epístolas

Un día quise saber ciertas certezas
Por qué las sinagogas en el Caribe
Tenían los pisos de arena
Las vi en Curaçao y en Barbados
Me imaginé a madres e hijas
Danzando sobre las arenas del Caribe
Y de Dios

Cuando dejé mi país
Porque éramos todos
Unos sospechosos
Sin importar demasiado si éramos
Judíos o cristianos
Cuando no debíamos hacer ruido por las noches
Ni avisar de cambios de domicilios
Supe que esa arena en las sinagogas del Caribe
Era para confundir a los amigos de la inquisición que tenían
Esa costumbre de espiar a los judíos conversos que
Eran piadosos y rezaban sus verdades

La arena fina les permitía silencio a los judíos
Ser disueltos en una espesura suave
Para que nadie los viera
Para que nadie los oyera rezar
Para que sus voces fueran diluidas y que
Nadie reconociera ni sus pasos ni sus presencias
En esta edad que aún pregunta
Por qué aún los judíos del Caribe siguen
Con los pisos de arena

And his failure to answer my letters

One day I asked
Why the Caribbean synagogues
Had floors of sand
I saw them in Curaçao and Barbados
I imagined mothers and daughters
Dancing on the sands of the Caribbean
And of God

When I left my homeland
Because we were all
Under suspicion
Because whether we were Christians or Jews
We were not supposed to make a sound at night
Or tell others of our change of address
I learned that the sands of the Caribbean synagogues
Served to trick the friends of the Inquisition
Who would spy on the pious converts
Now "conversos" but forever Jews
Who told the truth in their prayers

The fine sand let the Jews move about in silence
Let them sink into its softness
So that no one might see them
So that no one might hear them pray
So that their voices might be diluted
Their footsteps unrecognized
Their presence unnoted
Still I ask at my age
Why do the Jews of the Caribbean
Still have sand floors

Mi historia más que respuestas
Encuentra fe en sus preguntas
Las respuestas quedan
En el silencio perpetuo
De los pisos de arena

Perhaps my faith rests
In the questions
The answers stayed there
In the perpetual silence
Of the floors of sand

Hollywood

Mi abuela y yo
Íbamos al cine
A las altas horas de la noche
Cuando la luna se retira
A soñar sus pasiones

Vestidas de diademas
Y abanicos pasajeros
Solíamos sentarnos en
Primera fila
Porque fui y sigo siendo
Una enana
Maliciosa
Ella porque su sordera
Ordenaba la proximidad de las cosas

Así conocimos íntimamente los rollitos
Cariñosos de Marilyn Monroe
El bigote delgadito de Clark Gable
Y la sexualidad de John Wayne
Que resolvía la vida con pistolas

Cuando acababa la función
Discutíamos sobre el final
De las películas
Y cuando ella no se sentía satisfecha
Con el destino de estos actores
Solía inventarse un final que me
Contaba hasta el amanecer

Hollywood

Late at night
When the moon was setting
My grandmother would take me
To the movies
To fulfill her fantasies of passion

Wearing diadems
And carrying Spanish fans
We would sit
In row one
For I was then as I am now
Short of stature
And mischievous
She was hard of hearing
And wished to be close

Thus we knew intimately
The wondrous curves of Marilyn Monroe
The little mustache of Clark Gable
And the sexuality of John Wayne
Who solved life's problems with a gun

When the movie was over
We debated its conclusion
And when dissatisfied
With the characters' fate
She invented an ending
And embellished it till dawn

Hasta que las dos abrazadas
Nos adormecíamos en el imperio
Soberano de nuestros propios sueños que
Eran aún más audaces que los de Hollywood

Till we fell asleep
In each other's arms
In the dominion of our dreams
More audacious
Than Hollywood's

La cocina

Mi abuela decía que
Prefería imaginar
La cocina
Sentirla desde lejos
Tan sólo reconciliarse
Con sus aromas

No era exacta en los
Ingredientes
Y describía a las delicias
Que llegaban a su mesa
Por sus colores
O por las horas en que se debían
Ingerir los alimentos

No le gustaban las lentejas
Las llamaba el consuelo de los pobres
Al flan
La leche azucarada de las delicias
Desconfiaba de la comida china
No sé lo que estoy comiendo
Decía
Cuando se trataba de las pastas
No inventaba demasiado
Decía que todo lo que tenía
Que ver con Italia era perfecto
Al dente
Picante

The Kitchen

My grandmother said
She would rather imagine
The kitchen
Sense it from afar
Interact only
With its aromas

She never measured
Ingredients
With exactness
And she described
The treats that appeared on her table
By their colors
Or by the time it took
To ingest them

She did not like beans
She called them the consolation of the poor
She called flan the sweetened milk of all treats
She was wary of Chinese food
I don't know what I'm eating
She said
Pastas
She liked
She said all things Italian
Were perfect
Al dente
Picante

Y así nombraba
A las comidas
Con pasión
Con ternura

Solía amar las cenas
Cuando la luz retiraba
Y la luna hacía sus reverencias
Decía que era de mal gusto
Comer con sol
O levantar el dedo meñique
Mientras se bebía el té

Thus she described
Her meals
With passion
With tenderness

She loved her dinners
When the light was waning
And the moon was rising
She condemned as unmannerly
Dining
Before sundown
Or sipping tea
With the pinkie pointing up

La tierra

Te preguntaba cómo era la tierra
Muy al fondo
Entre la angostura de la oscuridad
Y las aberturas de un cielo subterráneo

Sonreías
Decías que los gusanos gobernaban la vida
De los muertos
Que la tierra era huesuda y oscura
Pero para los que mueren con felicidad
Tierna y dulce

The Earth

I asked you what the earth was like
Deep down
Through the straits of darkness
To the opening of a subterranean heaven

You smiled
And said that worms governed
The life of the dead
That the earth was dark and bony
But soft and sweet
For those who die happy

La plaza de tu pueblo

Y la vida era
La plaza de tu pueblo
Con una orquesta
De ancianos clarividentes
Que celebraban los
Domingos con trompetas
Y camisas blancas

Tú y yo
Contemplábamos
Ese pasar de los días
Desde una banca generosa
En sus maderas
En la plaza del pueblo
Donde las mujeres
Bordaban historias
Imaginaban secretos
Mientras las gitanas
Descifraban las urdimbres de tus manos
Y un humilde viajero que tú
Creías caballero andante
Te obsequiaba un ramo de gardenias

En la plaza del pueblo
Donde el viento era
Caricia templada
Donde las penas tenían su
Compañía

The Plaza of Your Town

You lived your life
In your plaza
With its band
Of clairvoyant elders
In white shirts
Celebrating Sundays
With their trumpets

You and I
Would contemplate
The days there
On our long wooden bench
In the plaza
Where women
Embroidered stories
And imagined secrets
Where Gypsies
Deciphered the lines
Of your hands
And a humble traveler
Whom you thought a knight errant
Gave you a bunch of gardenias

In the plaza
Where the wind
Caressed gently
Where sorrows found
Company

Hoy regreso a ella
Tú no estás
Pero llega un colibrí
Y un humilde viajero te recuerda
Mientras me ofrece a mí
Tus gardenias

Today I return
You are not there
But a hummingbird appears
And a humble traveler
Remembers you
When he offers me
Your gardenias

La prisa

Decías que no era
De buen gusto
La prisa
Como caminar velozmente
Actuar ocupada
Aparentar los miles de oficios

Tu ritmo era
Un río de luz
El placer en lo
Inesperado
El ahora

Haste

You said that haste
Was in poor taste
Like walking fast
Acting busy
Pretending to have a thousand things to do

Your rhythm was
A river of light
Your pleasure
The unexpected
The now

El café

De todas tus ocupaciones
La verdadera vocación
Era ir al café
Siempre al mediodía

Llegabas al café
Como una soberana
Sensible a los que
Contaban tristezas y
Bendiciones

Con elegancia
Con dulzura
Escuchabas

Llego al café de la esquina
No estás
Pero igual te saludo
En tu hora
A las doce del día
Cuando la ciudad
Hace una pausa para recordarte
Abuela mía
Reina mía

The Café

Of all our activities
You loved the café visit
The most
Always at twelve noon

You would arrive at the café
Like a monarch
You sympathized
With those who recounted their misfortunes
And blessings

With elegance
And sweetness
You listened to them

Now I go to the corner café
You are not there
But still I greet you
At your hour
Twelve noon
When the city pauses
To remember you
My grandmother
My queen

Mi abuela murió en Chile

Mi abuela fue prudente
En sus viajes
Le gustaba proveer
De alimentos
Almendras nueces azafrán
Y otras especies
Para colorear la vida

Temía ella a los parajes extraños
A los idiomas que daban órdenes
En vez de caricias

Le preocupaba
El destino de su pueblo
Y solía preguntar
Si era bueno o malo
Para los judíos
Viajar a lugares extraños

Desconfiaba de mapas
Porque desaparecían con la misma rapidez
Que otros países
Desconfiaba de ciertos ríos y mares
Porque sólo ofrecían
Refugios temporarios

Mi abuela prefirió
La paz junto a los jacarandas
El canto del gallo al amanecer

My Grandmother Died in Chile

My grandmother was wise
When traveling
She packed her own
Almonds walnuts saffron
And other seasonings
To spice up her life

She avoided strange places
And languages that commanded
More than caressed

She worried about the future
Of her people
And regularly asked
Whether it was good or bad
For Jews to journey
To foreign lands

She distrusted maps
For they vanished as quickly
As countries
She distrusted rivers and seas
For they offered refuge
Only temporarily

My grandmother loved
The peace of the jacarandas
The sunrise song of the rooster

Los limoneros en flor

Y las recetas de Estambul y Odessa
Entendió los viajes
A través del paladar
Sus memorias eran recetas

La abuela murió en Chile
Como una reina
En su cama de caoba
Junto a espejos y sombreros
Filtrando historias
Murió en español
Su idioma amado

Y yo quise saber
Qué país era bueno or malo
Para los judíos
Para después contárselo
Para asegurarle
Que ningún río se parece al otro
Que siempre se regresa
A un país que la recibe
Con el viento sobre la mejilla
Como un beso

The blossoms of the lemon trees

And the recipes of Istanbul and Odessa
She recalled her trips
By the taste of the food
Her memories were recipes

My grandmother died in Chile
Like a queen
On her mahogany bed
Beside her hats
In front of her mirrors
Recounting stories
She died in Spanish
In the language she loved

And I wanted to know
What country
Was good or bad for Jews
To tell her later
To assure her
That no river resembles another
That every river returns
To a land that will take her in
Where the breeze will brush her cheek
Like a kiss

SECCIÓN IV
Ahora que no estás

SECTION IV
Now That You Are Not Here

El alma busca lugares

Dicen que cuando el cuerpo reposa
El alma busca lugares

Hoy te vi
En una mariposa
Cobriza
Como tu cabello

Llegaste sola
Ingenua
No esperabas reconocimientos
No pedías nada
Pero sé que eras tú
Vestida de mariposa
Con tus alitas cansadas
Con tu mirada de fuegos y cenizas

Dicen que cuando el cuerpo reposa
El alma es una mariposa

The Soul Seeks Places to Be

They say that when the body rests
The soul seeks places to be

Today I saw you
In a butterfly
Copper-colored
Like your hair

You arrived alone
And ingenuous
You expected no acknowledgment
You asked for nothing
But I know it was you
Dressed as a butterfly
Your wings weary
Your gaze of fire and ash

They say that when the body rests
The soul is a butterfly

Los cumpleaños

Te gustaban los cumpleaños
Y celebrabas el mío
Origen de la vida breve y extensa
Fuerza ancestral de la permanencia
Impermanente

En cada cumpleaños
Desafiante
Leías mi porvenir
Mis manos se posaban
Sobre las tuyas
Espejos de tiempos trenzados

Decías
Que todo lo que bien brilla
Viene desde adentro
Como los ríos que abren sus brazos
Para quien aprende a mirar
Desde el fondo del agua
Solías obsequiarme
Estrellas de mar
Almanaques
Bitacoras antiguas
Caracolas extraviadas
Pájaros de madera

Aprendí entonces a amar esas cosas
Objetos sin tiempo preciso
Con pequeñas historias fabuladas

Birthdays

You loved birthdays
And you celebrated mine
Birthdays mark the origin of life
Its permanence
Its fleetingness

On every birthday
You foretold my future boldly
Our hands intertwined
Like our lives

You said
Whatever really sparkles
Glows from within
And we learn to see it
The way we peer
Into the depths of a river
You would give me
Dried starfish
Almanacs
Antique binnacles
Conch shells
Wooden birds

I learned to love those things
Objects of indiscernible age
Embodiments of fabulous stories

Cantábamos canciones a una voz
Y me decías
Que no hay ni futuro ni pasado
Sólo el instante
La fe del ahora
El ya de la felicidad

Si la vida era breve
Decías
No era asunto nuestro
Lo esencial era creer en lo transitorio
Jugar mucho
Olvidar el tiempo

En este cumpleaños sin ti
Diálogo con tu voz y tu sombra
Te imagino en una embarcación fantasma
Que llega a otras orillas

Hoy te llamo
Y tan sólo mi voz
Me contesta
Como el eco de un espejo

Me miro al espejo
Sigo tus consejos
Al saludar victoriosa

We sang with one voice
And you told me
There is no future
There is no past
Only the present
Have faith in the now
The moment of joy

If life is short
You said
That is not our business
What matters is to believe
In the ephemeral
Play much
Forget time

On this birthday
Without you
I converse with your voice
And your shadow
I imagine you
On a ghostly vessel
Landing on other shores

Today I call you
And my voice alone
Responds
Like an echo from a mirror

I gaze into the mirror
And follow your advice
salute the passage

El paso de un año más
Ahora sin ti

No estás conmigo
Abuela
Esta vez la muerte nos ganó el partido
Pero no derrotó a la memoria

De pronto
El viento mece mi rostro
Con una pluma violeta
Como la de tus abanicos

Pongo la mesa
Pongo un pastel adornado con mariposas
Al centro
Un puesto de honor para ti
Y de pronto
Siento tu olor a violetas
Entre mis manos

Tú has llegado
Soberana
Has llegado como un huésped
A quien se espera con anhelo
Y de pronto el sol
Ilumina la mesa de madera
Con tu olor a violetas
Sobre el mantel de mariposas

Of one more year
But without you

Grandmother
You are with me no longer
This time death won the game
Though not your memory

Suddenly the wind
Blows a feather
Across my face
Lavender
As if from your fan

I set the table
Put a cake adorned with butterflies
In the center
Make a place of honor
For you
And suddenly I smell violets
On my hands

You have arrived
My monarch
Like an eagerly awaited guest
Now the sun
Brings light to the table
And your scent of violets
To the tablecloth of butterflies

El Belloto

Más allá de las sombras
Ya no eres un huésped sobre la
Tierra
Sólo una presencia

Ahora estás en el panteón
Del cementerio judío
En el Belloto
Junto a hermanos
Y sobrinos

Se visitan
Con frecuencia
El viento de Dios
Les trae noticias

Yo te imagino en el panteón
Del cementerio judío
Cerca de un árbol que te cobija
Del sol del mediodía
Has permanecido
Y regresado a tu tierra
Y a tu nombre
Te llamas Hanna
Estás en el jardín
Fuera de todo peligro
Fuera de toda duda

Belloto

Beyond the shadows
You are no longer a guest
Upon the earth
But a presence

Now you are in the pantheon
Of the cemetery for Jews
In the Belloto
Near your siblings
Nieces and nephews

You visit with each other
Frequently
The wind of God
Brings you news

I imagine you in the pantheon
Of the cemetery for Jews
Near a tree that shelters you
From the midday sun
You have remained
And returned
To your land
And to your name
You call yourself Hanna
You are in the garden
Beyond all danger
Beyond all doubt

Y tu cuerpo habla en la
Noche
Y la noche envuelve a tu cuerpo
Como un salmo sereno

And your body speaks
In the night
And the night wraps your body
Like a peaceful psalm

Hierbabuena

Ahora que te pareces
A las mentas
A la hierbabuena
Te huelo toda
Te como toda
Mi niña vieja
De cabellos verdosos

Para besarte
Me arrodillo
Mi mirada
Y la tuya
Se reconocen
Me hago yo también
Pequeña
Quiero ver el mundo
Desde tu tamaño

Mint

Now that you have become
Mint of the earth
I can smell you
I can taste you
Old child
With hair of grass

To kiss you
I kneel
My gaze
And yours meet
I make myself small
To see the world
From your height

Se aplaca el deseo

Y ya no regresas
Y ya no acudes
Ni llamas
Se aplaca el deseo
Los que te conocen
Recuerdan la larga vida
Es un instante ida
Y ya no llamas
Pero te llaman
Y ya no escuchas

En vano retenemos
Tu voz
Tus palabras
El vestuario del último día
La camisa de dormir que cubrió
Tu última noche
Tu último aliento en esa
Lejanía de la vejez

Y ya no hay nada
Más que esta lucha contra el vacío
La creencia que la memoria
Te regresará
A una tierra también celeste

Desire Is Appeased

And you don't return
And you don't appear
You don't call
Your desire is appeased
Those who know you
Remember a long life
In an instant gone
And you don't call
Though we call you
And you don't hear

In vain we try to retain
Your voice
Your words
The clothes you wore on your last day
The nightgown you wore on your last night
Your last breath
In the remoteness of old age

And now there is nothing
But this struggle against emptiness
The belief that memory
Will bring you back
To an earth
That is heavenly too

Los años

Los años te hicieron
Audaz
Desacatada
Enemiga de los falsos
Rituales
Apasionada ante la idea
De la esperanza

Tu risa se hizo
Cada vez más como
Una campana
Campana con sonido
Del mar Pacífico

Te teñiste el pelo verde
A veces violeta
Te pintaste los labios color
Pasión
Te compraste un sombrero alado
Juguetón

Cambiaste tu oro
Por las caracolas y estrellas de mar

The Years

The years
Made you
Audacious
Irreverent
The enemy of empty formalities
Passionately optimistic

Your laughter
Became like a bell
A bell with the sound
Of the Pacific Ocean

You dyed your hair green
And violet on occasion
Painted your lips the color
Of passion
Bought a broad-brimmed playful hat

You exchanged your gold
For seashells and starfish

Frente

Entonces
Me acerqué a tu frente
Ya helada como en
Los jardines de la sombra
Yacía
Te besé
Como lo hacíamos
En los despertares
Queriéndonos con la suavidad de
Los comienzos
Tu cuerpo envuelto en la sábana blanca
La vela como tus ojos
Mariposas tristes extraviadas
Y aunque no pude negar a la muerte
Ni evadir su llegada
Te besé en la frente
Como si fuera de día

Forehead

Then
I approached your forehead
That lay there
Already cold
Like a garden in shade
I kissed you
As once we kissed
When we awoke
Caring for each other
With the sweetness
Of beginnings
Your body encased in a white sheet
The candle like your eyes
Sad stray butterflies
And although I could not deny death
Or prevent its arrival
I kissed your forehead
As I would on any other day

El rezo de una memoria

Más allá de la noche
Del otro lado del tiempo
Reposas
Aprendes a nombrar
La tierra que te mece
Ya nada temes
Estás vestida de cosas
Diáfanas
La oscuridad se deleita
Ante tu luz
No hay muros
Ni fronteras
Más allá de la noche
Y el día
Eres una caricia
El rezo de una memoria

A Memory's Prayer

Beyond the night
On the other side of time
You rest
You learn to name
The earth that cradles you
You fear nothing now
You are dressed
In diaphanous things
The darkness is pleased
By your light
There are no walls
No borders
Beyond the night
And the day
You are a caress
A memory's prayer

Entre los pinos

Entre los pinos
El viento
Y su promesa de luz
A lo lejos alguien
Canta un salmo
Y es dulce esa melodía
Que conjura tiempos
Atuendos invisibles
A lo lejos el viento
Dejando ofrendas
Brindando trozos de cielo
Hacia la tierra
Despojos que florecen

Pongo mis manos en tu tumba
Como antes lo hacía sobre tu cuello
Y es imposible pensar
Que no continúas aquí

Como una soberana
Sobre la tierra
Ahora vives
Sólo en los gestos
De la memoria

Y tu tumba aún está tibia
El sol reposa sobre las
Antiguas letras del
Alfabeto hebreo

Among the Pines

Among the pines
The wind
Promises to bring light
Far away someone
Sings a psalm
And the sweet melody
Evokes murmurs from other times
Far away the wind bears gifts
Offerings of the sky to the earth
That flower

I place my hands on your grave
As I once placed them on your neck
And I cannot believe
You are no longer here

Like a sovereign
Of the soil
You live now
Only in the gestures
Of memory

And your grave is still warm
Sunshine falls on the ancient words
Of the Hebrew alphabet

Que yo leo en voz
Alta
Y canto

Canto tu nombre
Canto las letras
Todo parece regresar a un
Principio claro
No hay sombra en tu tumba
El sol se acomoda a tu cuerpo
No quiere dejarte
Ni sola ni vacía

Y yo me acomodo a tu presencia
Entre los pinos
En el antiguo cementerio
Del Belloto
Donde los rabinos invisibles
Vuelan por el aire
Cantan salmos
Y tu peregrina en descanso
Sueñas el sueño de los vivos

Which I read
And sing

I sing your name
I sing the words
Everything seems to revert
To its origins
There is no shadow on your grave
The sun wraps round your body
And will not leave you
Alone or empty

And I wrap round your presence
Among the pines
In the ancient cemetery
Of Belloto
Where the invisible rabbis
Fly through the air
And sing psalms
While you
Pilgrim at rest
Dream the dream of the living

Adiós

Ahora que no estoy
Soy
Estrella
Cuajo de luz
Relámpago
Agua
Memoria
Elegía de las
Cosas
Vivas

Good-bye

Now that I am not here
I am
A star
A flash of light
Lightning
Water
Memory
Elegy for
Things
Alive

About the Author

Marjorie Agosín is Professor of Spanish at Wellesley College. She has published more than 20 books of poetry, eight books of memoirs, and six books of fiction—in Spanish and in English. Her memoirs include *Always from Somewhere Else: My Jewish Father; Celebration of Memory: Growing Up Jewish in Latin America; The Alphabet in My Hands; A Cross and a Star: Memoirs of a Jewish Girl in Chile*; and *Uncertain Travelers: The Jewish Emigrant Experience in the Americas*. In 2002 she co-edited with Betty Jean Craige a volume of essays titled *To Mend the World: Women Reflect on 9/11*. Her creative and scholarly work is featured in numerous anthologies. She has received the Gabriela Mistral Medal of Honor (for lifetime achievement), the United Nations Leadership Award in Human Rights; designation as the Katharine R. Dodge Poetry Festival Featured Poet; the First Prize for Poetry from *Letras de Oro*; the Latino Literature Prize; the Mexican Cultural Institute Prize for editing *Anthology of Mexican Women Writers*; the American Association of Literary Translations Award for *Circles of Madness*; a Peabody Award for Best Documentary, based on *Scraps of Life*; and the Henrietta Zolds Award from Hadassah. In 1996, Agosín was the subject of a Gem International 30-minute program titled *The World of Marjorie Agosín*. In 2003, she was named a "Leading Lady" of Boston. And in 2004 she was honored by the National National Hispana Leadership Institute with it's 2004 National Mujer Award .

About the Translator

Betty Jean Craige is University Professor of Comparative Literature and Director of the Center for Humanities and Arts at the University of Georgia. She has published books in the fields of Spanish poetry, modern literature, the history of ideas, politics, ecology, and art. Her early work as a hispanist included a study of Federico García Lorca's surrealist poetry, titled *Lorca's Poet in New York*, and book-length translations of the poetry of Antonio Machado, Gabriel Celaya, and Manuel Mantero. *Reconnection: Dualism to Holism in Literary Study*, for which she won the Frederic W. Ness Award from the Association of American Colleges, and *Laying the Ladder Down: The Emergence of Cultural Holism*, for which she was a co-recipient of the Georgia Author of the Year Award, explore the development in the twentieth century of a holistic understanding of culture and nature. *American Patriotism in a Global Society* examines the relationship of "political holism" to globalization. Recently she has published a biography titled *Eugene Odum: Ecosystem Ecologist and Environmentalist*, an art book titled *Alvar: Thirty Years of Lithography*, and a volume of essays, co-edited with Marjorie Agosín, titled *To Mend the World: Women Reflect on 9/11*. She is also Co-Founder and Co-Director of the Delta Prize for Global Understanding.

DISCARDED